The first permanent settlers along the Chicago River didn't do much drawing. There were too many furs to trade, forts to build, canoes to paddle for anyone to pick up a pencil, and somehow that feels true to the "City That Works." But it means my favorite image of early Chicago—titled *Chicago in 1779*—is entirely a fiction, an aquatint created some 150 years later by a French artist named Raoul Varin. Looking from the east, he gives us the blue lake lapping at the sandbar that once guarded the river's mouth, a small Indigenous settlement to the south, Jean Baptiste Point DuSable's cabin to the north, and the river pushing back west toward Wolf Point until it splits and the prairie takes over, rolling toward the horizon.

What made me truly love this image was one small, wildly ahistorical detail among all the out-of-whack proportions and inaccuracies, such as the six-foot-wide river. A figure I'd assumed to be DuSable stands in front of his cabin arms outstretched, the setting sun casting his shadow. It's not the sun he's besotted with, though; he's not facing west. He's facing south toward what will become the city of Chicago. If there are stinky onions out at Wolf Point, he doesn't smell them. The next brutal winter is far off on the other side of the soft, gorgeous autumn on its way. No, something great is inevitable here where the deep blue lake meets the sky and the prairie, and he *sees* it. I couldn't decide whether this was just DuSable in love with the place or if Varin was showing us an imaginary golden hour when Chicago's first settler began to magically conjure the city into being.

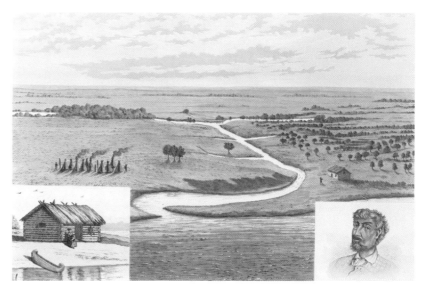

Chicago in 1779 with Portrait of Jean Baptiste Point DuSable. Chicago History Museum, ICHi-001187; Raoul Varin, engraver.

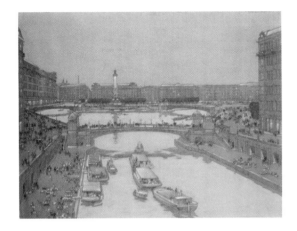

View Looking North on the South Branch of the Chicago River by Jules Guérin. Chicago History Museum, ICHi-003547.

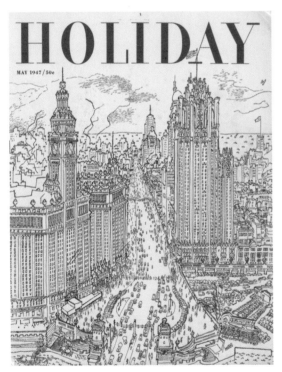

HOLIDAY

MAY 1947 / 50¢

This 1947 cover of the international travel magazine *Holiday*, which features Jose Bartoli's drawing of Michigan Avenue, is emblematic of how Chicago was portrayed in the popular media of the time.

Ryan Chester's remarkable drawing starts right about where DuSable stands in Varin's aquatint. Your viewpoint on the opening page is what I imagined DuSable's viewpoint to be, and when I saw it, I couldn't help but wonder what he'd make of the place now, all its speed and steel. Could he really have imagined even a fraction of it today? Either way, Chester has joined a line of artists who have helped generations understand what Chicago is and imagine what it could be by putting their dream cities on paper. Jules Guérin's moody renderings for Daniel Burnham's *Plan of Chicago* set the tone for decades of triumphalist aspiration. The romantic Catalan Jose Bartoli, Spanish Civil War veteran and Frida Kahlo's lover, drew a Chicago percolating with post–World War II energy. And Franklin McMahon stepped out of the courtrooms where he'd drawn some of the city's most famous trials to depict a seventies Chicago trying to crawl out from under the Richard J. Daley years, toward openness and optimism.

And, of course, there's Varin, who was the only one actually doing any conjuring in that aquatint. He created it in 1930 as part of an extremely popular series that you can still find on the walls of old clubs around town. Most were copies of engravings made by an earlier team of Scandinavian immigrants named Otto Jevne and Peter Almini. Published together as *Chicago Illustrated* in 1866–67, these engravings are the best views we have of pre-fire Chicago. But *Chicago in 1779* wasn't one of theirs. It seems that Varin came up with it himself in his studio on the Left Bank of Paris.

Like all these artists, Ryan Chester works at the intersection of real and imaginary, of what the city is and what it can be. His Chicago is no one's but his. Growing up in Milwaukee, he surrounded himself with his own drawings, and cities were what he loved to draw: streets and skyscrapers, real cities and dream cities. Chicago was a paradise to him and his greatest inspiration. This is evident throughout his other work, where his subjects are usually buildings and the choreography of lines they create when they stand next to each other; that Chicago, for all its tall buildings, is a homey, welcoming place and just about the exact opposite of Hugh Ferriss's dark, looming Manhattan. With a direct and honest address, Chester gives Chicago light and room to move, a sense of intimacy, and an understanding of the pride Chicagoans have for their home.

The drawing in this book, though, is a departure for Chester. It's epic and in some ways unsettling, and that's what makes it wonderful and important. I'll never get tired of all the ways of seeing Chicago's skyline: coming in on the Kennedy or Dan Ryan, looking south from Lincoln Park or west from the planetarium, or dropping through the clouds on your approach to O'Hare. Without (yet) the plague of supertalls that has turned New York's skyline into so many beanstalks to the clouds, the Chicago skyline seems to still belong to Chicagoans. But rather than doling out the pleasures of recognition with another expected vista, Chester situates us in a place most of us aren't entirely accustomed to even though we've always known it was there—the banks of the Chicago River. Instead of the standard sailing-along-the-lake view, Chester takes us on a brief journey into the working heart of the city, reminding us of its history and original purpose as the connection to the Mississippi. This isn't the view—or the city—we take for granted. This is where Chicago is Venice, water splashing at the windows, where it's a fjord between steel cliffs, and where the ways the city has changed since DuSable are most evident. The masts and sails that made Chicago rich are long gone; now it's a pleasure coast for tourists and whoever's still working downtown.

Matteo Pericoli's *Manhattan Unfurled* (2001) is an obvious comparison, but Chester's isn't a whimsical take on the skyline genre; it's something much more subtle and challenging. While you can sail along the Hudson and see New York's shoreline from Pericoli's exact perspective, the Chicago we see in Chester's drawing is in fact an impossible place. There are multiple vanishing points, for example, and there is no way to take in the shores of the river from the distance he's drawn them at. The bridges fly past at different angles; one has an "L" train about to fall in. He has restored the elegant Union Station Concourse Building torn down in 1969, Dirk Lohan's fountain sprays cheerfully again at Centennial Plaza, and the *Eastland* has been resurrected for the happy day trip to Michigan City that it was meant to take.

This is all more than just a fantasy vision. Chester's Chicago is impossible so that it can tell the truth. In Italo Calvino's brilliant *Invisible Cities*,

Marco Polo describes city after impossible city to the Kublai Khan, all of which are aspects of Venice and all of which are the truths of *all* cities. The truth here is not just in the hyperdetailed rendering of the shores of the Chicago River, because this isn't a snapshot. There's no pretense that this Chicago is a final product. Not only does Chester play with time; he's stopped it. There are stamps of that through-out—110 North Wacker (aka the Bank of America Tower), for instance, is still under construction, and the Reed near Bertrand Goldberg's River City hasn't even broken ground. As I write this, Salesforce Tower at Wolf Point has topped out, but here there's just a massive crane. By the time you read this, other buildings may have come and gone. The reason is that Chester started this project in March 2020, when Chicago—like all cities—was impossibly silent and maybe, some thought, suddenly impossible altogether.

Yes, there are boats and some kayakers paddling along the South Branch here, but there are no people on the streets or bridges, walking on the Riverwalk, or waving from office windows. In these pages I feel those dislocating days of empty streets and abandoned buildings, the deep intake of breath we all took when unimaginable things became normal. That's the moment Chester freezes here—that instant of breath held between inhale and exhale, a moment of fullness and suspension, of the end of something and the beginning of what's next. The sky has been turned into a vast open space with no clouds or sun or hint as to which way the wind is blowing. He has caught this moment so that we never forget it, and we must ask ourselves, standing where DuSable once stood: What's ahead for this place we love?

All this Ryan Chester does as more than an artist and maybe not as an artist at all. He's an architect and has practiced in New York, London, and, of course, Chicago. So this work also operates at another unique intersection—the one between art and architecture. On one level it almost serves as a catalog of the city's buildings and architects; just about all the big names of the twentieth and twenty-first centuries are here to be found, from the titans Mies van der Rohe and Goldberg to stars of today like Jeanne Gang and Adrian Smith. The methodical style of the drawing itself, each building given its full due, pulls deeply from the lineage of architects who have literally drawn Chicago into exis-tence, who used drawings to express essential aspects of their buildings and the city around them.

There is definitely Mies here, at least in spirit, in the philosophy taught at the Illinois Institute of Technology, where the first-year students drew seemingly endless rows of precise bricks in a manner that approached spiritual practice. One can sense in Chester's intricate, almost obsessive rendering of the towers along the river—window by window, mullion by mullion—someone crawling into them to learn just how they were made. In terms of pure style, he's closer to Alfred Caldwell, who taught for decades at IIT under Mies and illustrated Ludwig Hilberseimer's books with a similarly ferocious attention to

detail, down to filling in trees leaf by leaf. Chester's rendering also has some of the thrilling scale of Frank Lloyd Wright, whose drawings can feel like stage sets for the human drama, and though Helmut Jahn's self-conscious, cartoony drawings lean more toward the Chicago Imagists, Chester claims him as his greatest artistic influence.

Beyond any stylistic detail, though, Chester has a more important connection to these architects: he is one of the last architects who make drawing central to their professional practice. Virtually every step in the process of designing a building is now done on a computer, and parametric modeling can pour out dozens of alternatives in one go. There's no need to convince me that this modeling makes sense, is economical and time-saving, and produces excellent buildings—it does all of that without question. Digital technologies help us stretch our imaginations in new ways. But things like parametric modeling can also reduce design to mere problem-solving. The act of taking an idea and turning it into line and shadow using your hand and a pencil opened a very human kind of channel from information to understanding, and drawing all those bricks for Mies taught the hand how to access that channel. I'm certain one could design a program to replicate Louis Sullivan's system shown in *Manipulation of the Organic*, but the organic would be gone. And isn't that the Whitmanesque point, really, of Sullivan's drawings? That we can fire our dreams into terra-cotta and live among them? Chester's piece asks us to consider what we will lose when architects like him put down their pencils forever.

So here is that silence again, the collective breath held on the brink of something ending, as we look at a Chicago we've never seen before and never will again. Through the silence Chester has given his buildings—massive, seemingly eternal buildings—these structures teach the law of impermanence. They ask, as DuSable in Varin's image and Guérin's heroic visions of the City Beautiful also do, what will Chicago be?

It's a lot to ask from a drawing. But I don't think it's too much. At the very end of *Invisible Cities*, as Kublai Khan worries that the city's fate is to be damned, Marco Polo finds hope. We must, he says, "seek and learn to recognize who and what, in the midst of the inferno, are not inferno, then make them endure, give them space." Ryan Chester makes the buildings of Chicago endure. He gives them space.

But answering that question—what will Chicago be?—is on us. And a lot of it comes down to what we're looking for, what we want to see. Maybe all drawings are a kind of Rorschach test. When I finally sat down with that aquatint and took a good close squint at DuSable, I saw that he's not exactly greeting the future; Varin has him stalking off north, back turned, shoulders hunched, expressing what looks more like deniability than optimism.

Of course, neither one of them really happened. But I can't unsee that hope.

So I'm sticking with mine.

THOMAS DYJA

September 2022

ACKNOWLEDGMENTS

This book is dedicated to my wife, Elena, and my children, Maya and Anton.

Also, a special thanks to the three young architects who opened my eyes to start drawing Chicago, Ann Erskine, Vince Lee, and Juliette Zidek; to Tim Mennel at the University of Chicago Press, who took a chance on this project; and to Thomas Dyja for his beautiful words.

To my parents, Helen and Edward, who have always encouraged me to draw and provided me with the means to explore Chicago from an early age.

To the architects of the past and present who see the value of drawing as a means of communication and appreciate its beauty. In particular to Juan Moreno, who is a visionary working hard to enhance the quality of architecture in Chicago.

Finally, I would like to thank Mark Keane, professor emeritus at the University of Wisconsin–Milwaukee School of Architecture and Urban Planning, who inspired me in my college days to draw despite the trends of designing digitally.

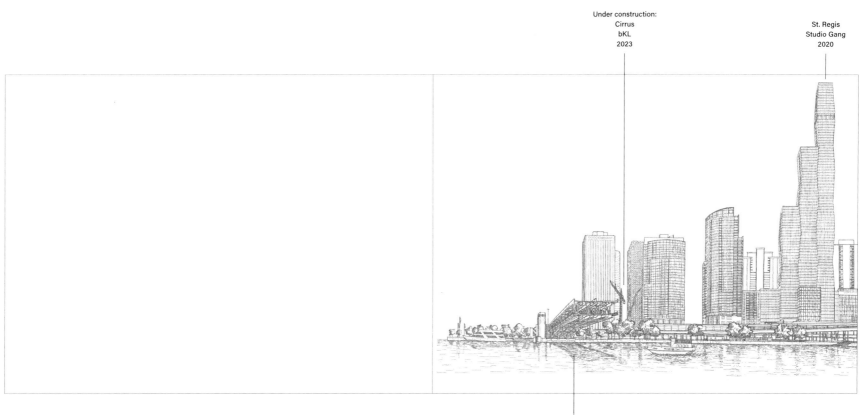

Under construction:
Cirrus
bKL
2023

St. Regis
Studio Gang
2020

Lake Shore Drive

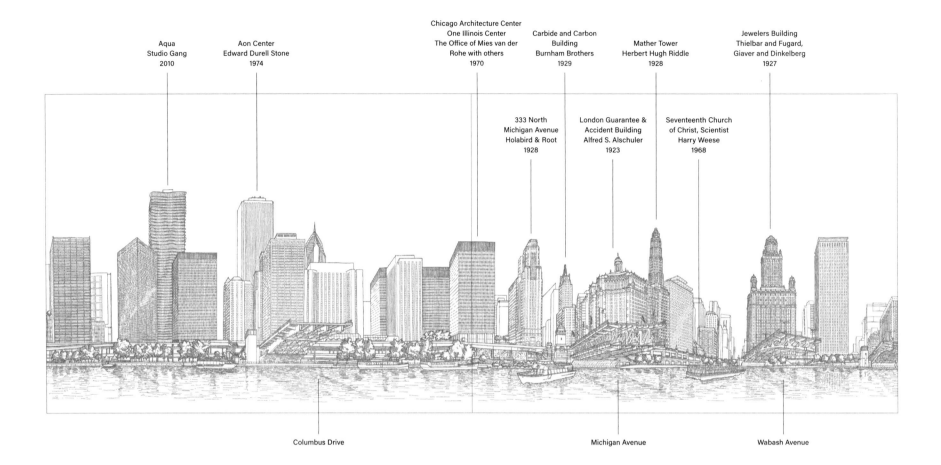

Aqua
Studio Gang
2010

Aon Center
Edward Durell Stone
1974

Chicago Architecture Center
One Illinois Center
The Office of Mies van der
Rohe with others
1970

Carbide and Carbon
Building
Burnham Brothers
1929

Mather Tower
Herbert Hugh Riddle
1928

Jewelers Building
Thielbar and Fugard,
Giaver and Dinkelberg
1927

333 North
Michigan Avenue
Holabird & Root
1928

London Guarantee &
Accident Building
Alfred S. Alschuler
1923

Seventeenth Church
of Christ, Scientist
Harry Weese
1968

Columbus Drive

Michigan Avenue

Wabash Avenue

Leo Burnett Building
Roche-Dinkeloo
1989

77 West Wacker Drive
Ricardo Bofill Taller de
Arquitectura
1992

OneEleven
Handel
2014

222 West Wacker Drive
Graham, Anderson, Probst & White
1927
SOM
1986

225 West Wacker Drive
KPF
1989

333 West Wacker Drive
KPF
1983

191 North Wacker Drive
KPF
2002

121 West Wacker Drive
Holabird & Roche
1929

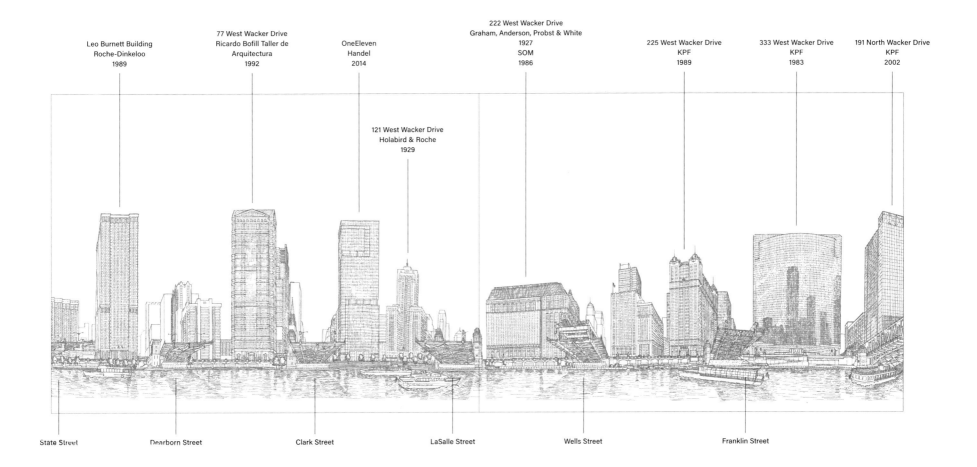

State Street

Dearborn Street

Clark Street

LaSalle Street

Wells Street

Franklin Street

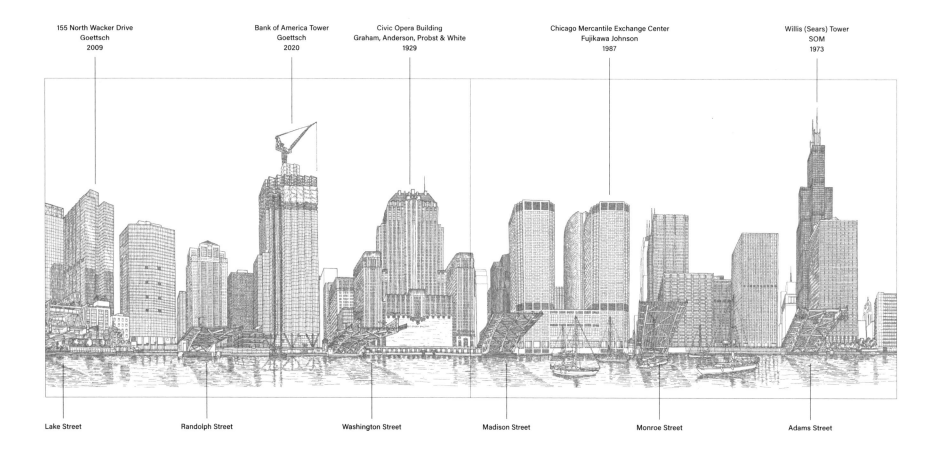

155 North Wacker Drive
Goettsch
2009

Bank of America Tower
Goettsch
2020

Civic Opera Building
Graham, Anderson, Probst & White
1929

Chicago Mercantile Exchange Center
Fujikawa Johnson
1987

Willis (Sears) Tower
SOM
1973

Lake Street

Randolph Street

Washington Street

Madison Street

Monroe Street

Adams Street

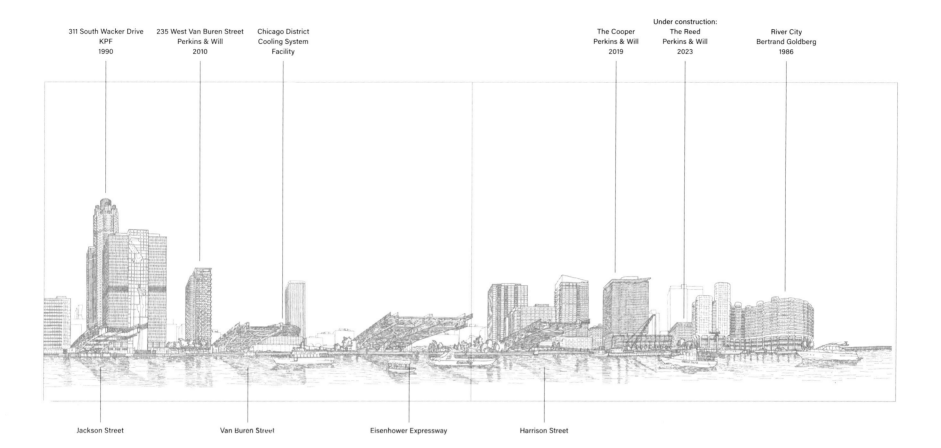

311 South Wacker Drive
KPF
1990

235 West Van Buren Street
Perkins & Will
2010

Chicago District
Cooling System
Facility

The Cooper
Perkins & Will
2019

Under construction:
The Reed
Perkins & Will
2023

River City
Bertrand Goldberg
1986

Jackson Street

Van Buren Street

Eisenhower Expressway

Harrison Street

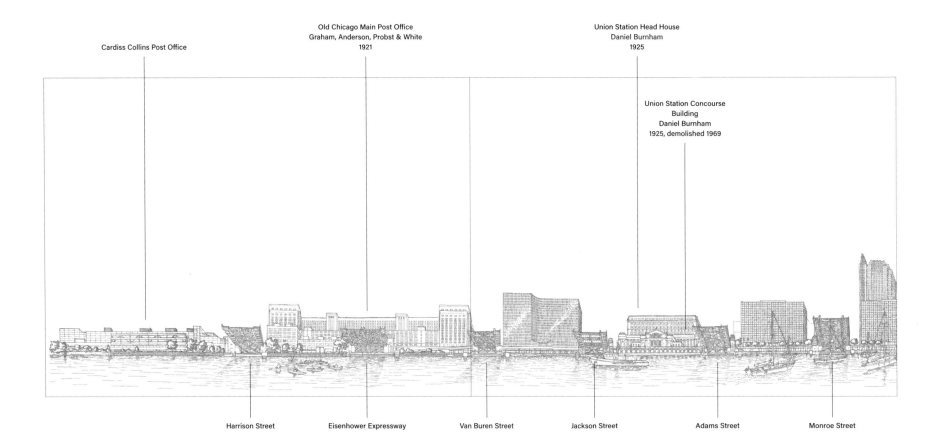

Cardiss Collins Post Office

Old Chicago Main Post Office
Graham, Anderson, Probst & White
1921

Union Station Head House
Daniel Burnham
1925

Union Station Concourse
Building
Daniel Burnham
1925, demolished 1969

Harrison Street

Eisenhower Expressway

Van Buren Street

Jackson Street

Adams Street

Monroe Street

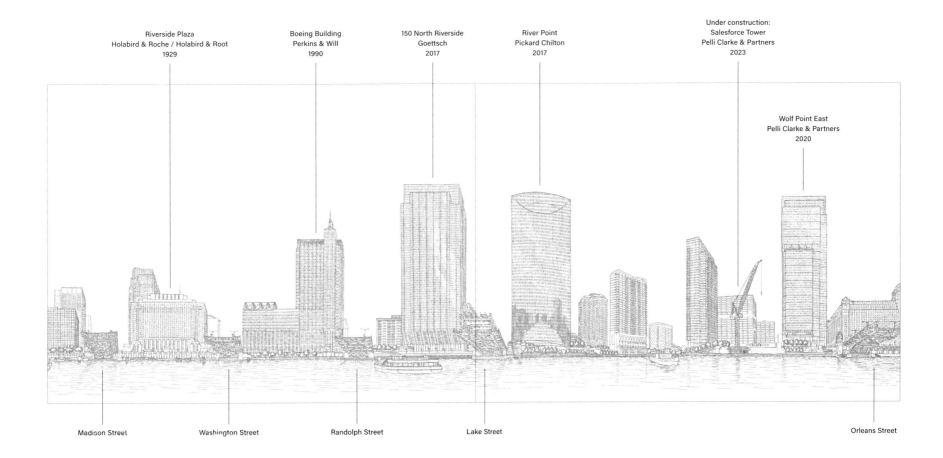

Riverside Plaza
Holabird & Roche / Holabird & Root
1929

Boeing Building
Perkins & Will
1990

150 North Riverside
Goettsch
2017

River Point
Pickard Chilton
2017

Under construction:
Salesforce Tower
Pelli Clarke & Partners
2023

Wolf Point East
Pelli Clarke & Partners
2020

Madison Street

Washington Street

Randolph Street

Lake Street

Orleans Street

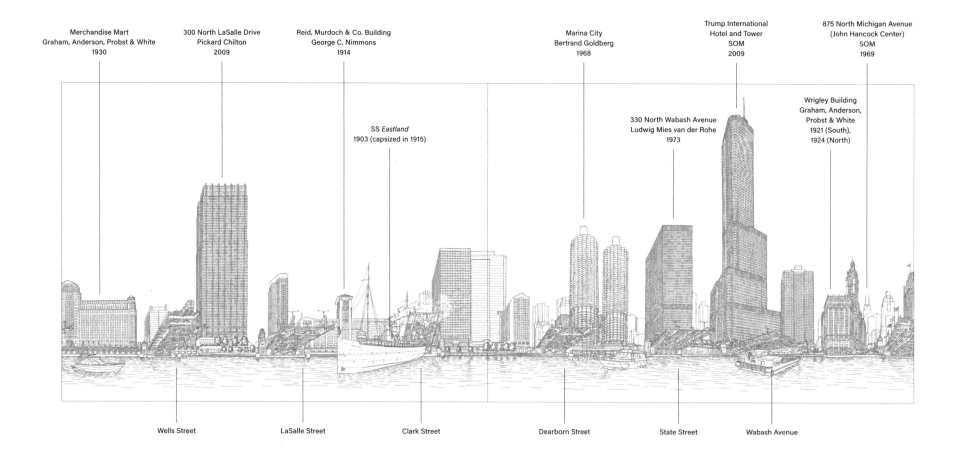

Merchandise Mart
Graham, Anderson, Probst & White
1930

300 North LaSalle Drive
Pickard Chilton
2009

Reid, Murdoch & Co. Building
George C. Nimmons
1914

SS *Eastland*
1903 (capsized in 1915)

Marina City
Bertrand Goldberg
1968

Trump International
Hotel and Tower
SOM
2009

875 North Michigan Avenue
(John Hancock Center)
SOM
1969

330 North Wabash Avenue
Ludwig Mies van der Rohe
1973

Wrigley Building
Graham, Anderson,
Probst & White
1921 (South),
1924 (North)

Wells Street

LaSalle Street

Clark Street

Dearborn Street

State Street

Wabash Avenue

Tribune Tower
Hood & Howells
1925

NBC Tower
SOM
1989

Centennial Fountain
Lohan Associates
1989

Lake Point Tower
Schipporeit & Heinrich
1968

Apple Michigan
Avenue
Foster + Partners
2017

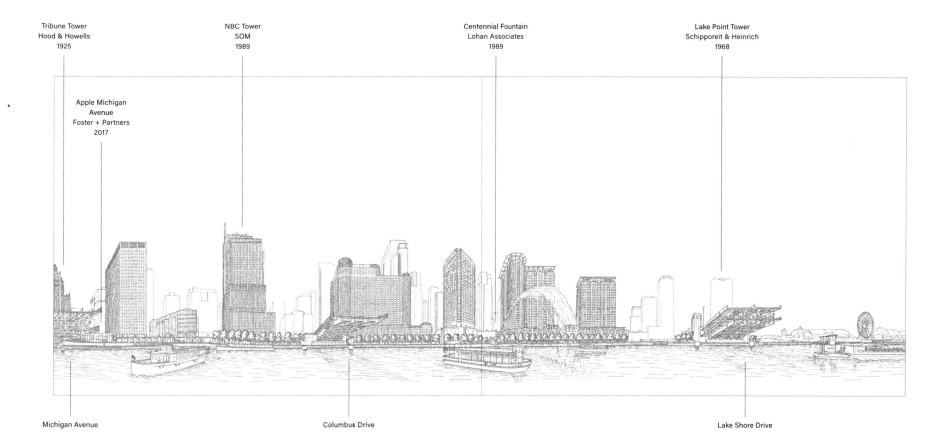

Michigan Avenue

Columbus Drive

Lake Shore Drive

Navy Pier
Charles S. Frost and E. C. Shankland
1916

Chicago Harbor Lock Building
AECOM
2007

Tall Ship *Denis Sullivan*
2000

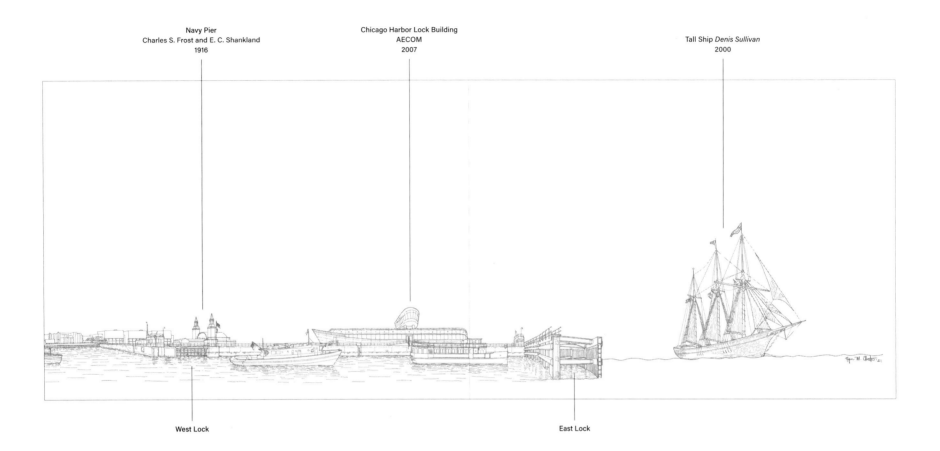

West Lock

East Lock